THE AFTER

THE AFTER

a poem by
MELINDA MUELLER

art
KARINNA GOMEZ

music
KATE OLSON & NAOMI SIEGEL

Entre Ríos Books
www.entreriosbooks.com
Seattle, Washington

The After
Melinda Mueller, Karinna Gomez, Kate Olson, Naomi Siegel

ISBN: 978-0-9973957-1-6 (paper)

End papers: endangered and critically endangered bird species, used with permission of
BirdLife International. (2016) IUCN Red List for birds at www.birdlife.org.datazone/species.

First Edition. ERB 003.
Printed in the United States by Olympus Press, Seattle·

In Memoriam

Dusicyon australis
1876, Falkland Islands

Conuropsis carolinensis
1918, Cincinnati, United States

Viola cryana
1930?, Yonne Département, France

Glaucopsyche xerces
1941? San Francisco, United States

Incilius periglenes
1989, Reserva Biológica Bosque Nuboso de Monteverde, Costa Rica

And all the rest.

*…we may feel certain that the ordinary
succession by generation has never once
been broken, and that no cataclysm
has desolated the whole world.*

Charles Darwin
On the Origin of Species, 1859

*Humboldt saw in South America
a parrot which was the sole living
creature that could speak a word of the
language of a lost tribe.*

Charles Darwin
The Descent of Man, 1871

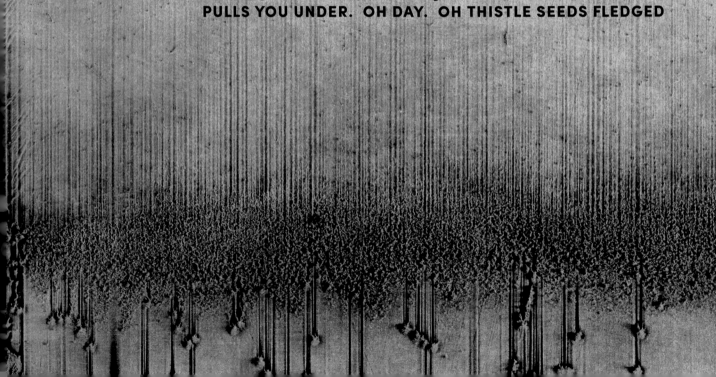

BEFORE

MONTANA. HIGH SUMMER. A SKY
YOU COULD STRIKE A MATCH ON. THE CRICKETS TUNED
TO THAT KEENING YOU HEAR JUST BEFORE THE ETHER
PULLS YOU UNDER. OH DAY. OH THISTLE SEEDS FLEDGED

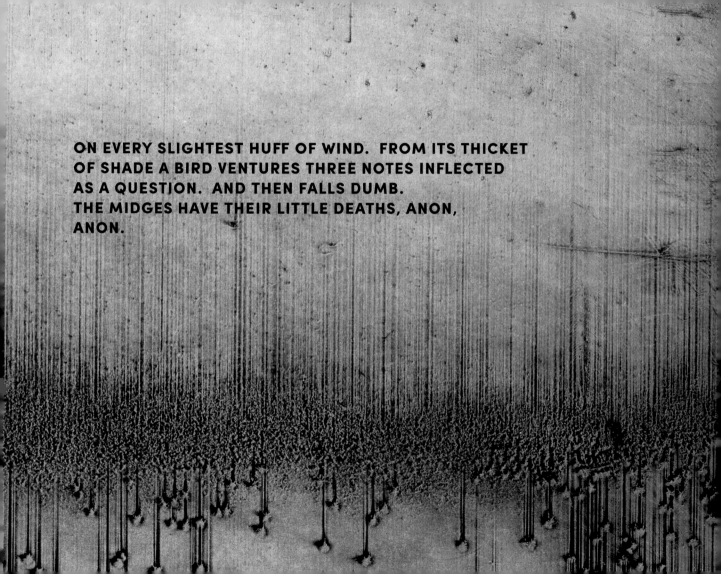

ON EVERY SLIGHTEST HUFF OF WIND. FROM ITS THICKET
OF SHADE A BIRD VENTURES THREE NOTES INFLECTED
AS A QUESTION. AND THEN FALLS DUMB.
THE MIDGES HAVE THEIR LITTLE DEATHS, ANON,
ANON.

THE AFTER

SPEAK, GENOA.
WHAT HAVE YOU DONE?

All
the words
have fall-
en
(golden
groves un-
leaving)
from
the trees
and blown a-
way

Radio waves roll out to infinity
bearing their flotsam …

 … shall fight in the hills; we shall never …

 … Such' ihn über'm Sternenzelt!
 Über Sternen muß er wohnen …

 … heavy on the turnpike …

 … O dark dark dark …

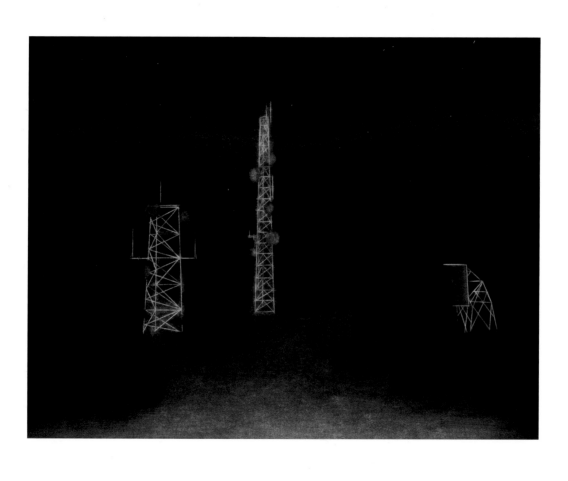

…Behind them nothing, only a long
hiss as of surf broken

on sand, without
form, and void.

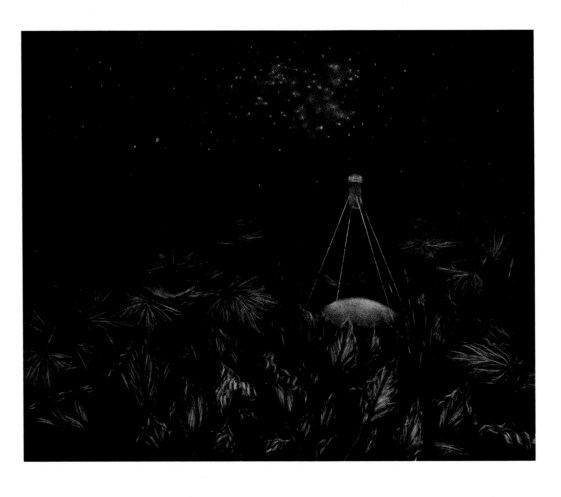

Yellow-naped Amazon parrots
spoke a common language,
though with regional dialects,

and spectacled parrotlets
named their nestlings,
no two of these signature calls
in a colony ever the same.

In the summer of 1903,
an observer in Nantucket overheard
a meadowlark singing
the first two bars of Aida's
Numi, pietà.

Commerce:
high tide comes in
in the night and rummages
through the beach folderol,
shuffling light, white shell shards
to the tidal verge, above green stuffs
of sea wrack and great-fisted cobbles. Sounds
in the dark hours of the business being done — silks
shaken out and gathered up, rattlings of dice,
occasionally the deep toll of a stone bell
rolled over. Morning, slack tide lolls
in indolence, its wares spread out
across the sand, picked over
by gulls and crows.

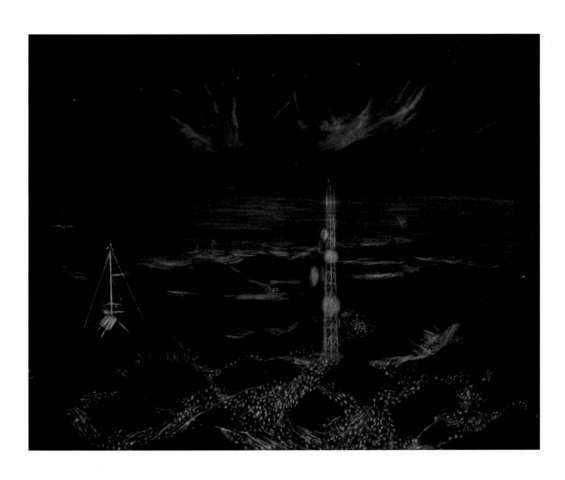

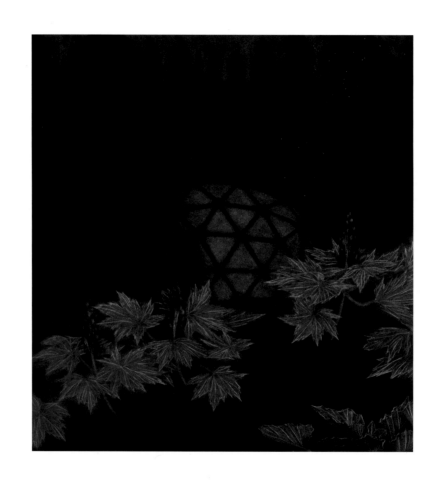

Whether the world is
just not quite fatal
hangs on such fine threads.

The shooting star primrose
gives forth pollen when a bee
hovers before its flowers,
thorax buzzing at 400 Hz.
Absent a G$^\sharp$ hum,
absent such a bee,
the shooting star fails
of progeny.

Inundated coastal forests
sway in cerements
of algae
under a shivered memory
of light.

Some things once named
persist,
nameless.

Some names
are orphaned without
correlatives.

Narthex,
unless
the first chamber
of a nautilus.

Staves,
unless staves
of rain striking
arpeggios on ferns.

GHOST GENES In birds a spectral code
for teeth.

Gill slits in the embryos of
mice.

Mishaps. Stutters. Palimpsests.

Lost tribes' still, small whispers
haunting the DNA.

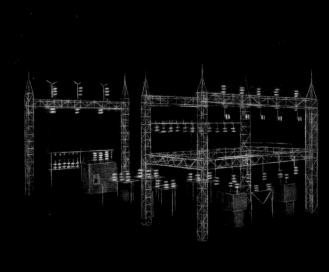

Everywhere
metabolic bewilderment

Air wiped blank
that was scribbled before
with pheromones

Wetlands struck dumb
of mating calls

Fireflies'
four dots / dot dash dot
four dots / dot dash dot
gone dark

Bonfires of extinction
coalesce
into an inferno

that burns itself
out,
in time.

Natural selection
rights itself,
and commences again
the work
of ages, creatures

changed utterly
that will never
be named.

Still trees cast forth their greeny nets
and haul in light

Still rivers ladle themselves over
brinks of waterfalls

Still the clinker-built pangolin
 gashes termite mounds for grubs

Still waves prostrate themselves upon the strand
as in grief or prayer

There are minnowings
in lake shallows

Still dust devils swirl up the ghosts
of all that ever was.

Here and there are *despoblados*

where an immortal death
burbles up in the eyes
of springs

where torn fire glares on beauty
with a rusted mouth

where sunlight's shaken
draperies stir up
a lethal dust.

Never has come to pass
in those places.

Thus, the laws of burial.

TAPHONOMY 1 The creature having been inhumed,
 the body's volatile compounds
 fume away leaving
 a shadow cast in carbon.

TAPHONOMY 2 The creature having been inhumed,
 bacteria invest the tissues
 with pyrite, shaping
 a burnished and faithful image.

TAPHONOMY 3 The creature having been inhumed,
 minerals — commonly silica, rarely
 opal — supplant every structure,
 forming a golem of stone.

Snow falls into the arms
of gravity,
the physical laws being
transcendent and innate.

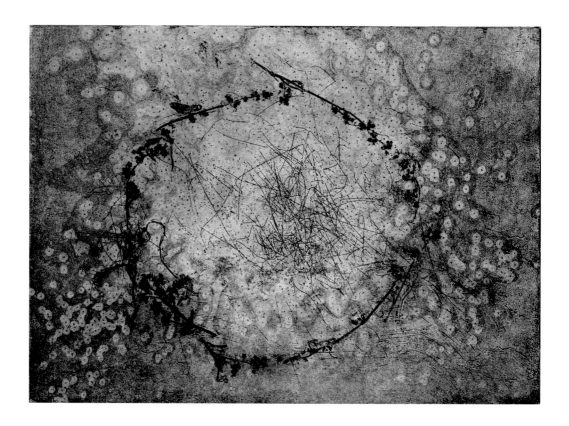

As beauty is.

At sunrise, lambent colors
exalt the under-flanks of clouds.
Unlooked at.
Undimmed.

By quantum entanglement

by mirror neurons

by $E = mc^2$

somewhere beyond Deneb α Cygni,
does a tiger look back over her shoulder
into a jungle of furious
green ideas

or pass into nothingness?

Future and past
having been sloughed off

the long now unfurls

The prey is seized
with terror
that dread does not foreshadow

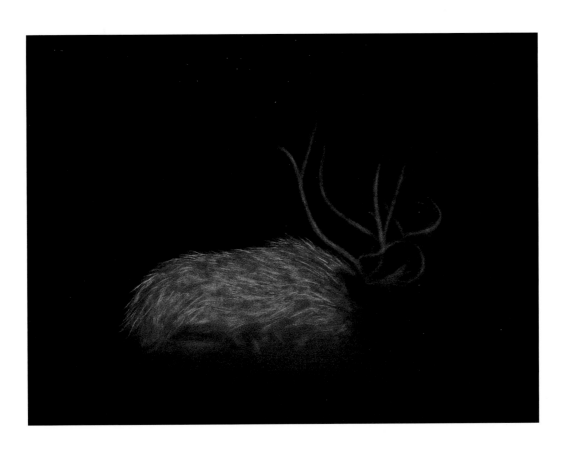

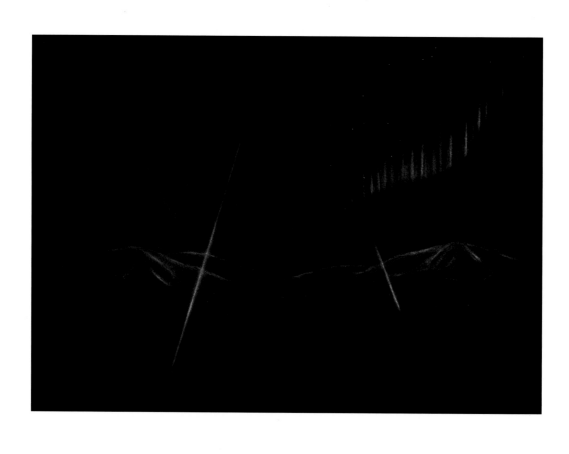

Losses befall
untarnished by regret

The present rises
from everything like
attar

A vermilioned
nothingness shatters
across badlands

as the sun goes down.

Deus absconditus.

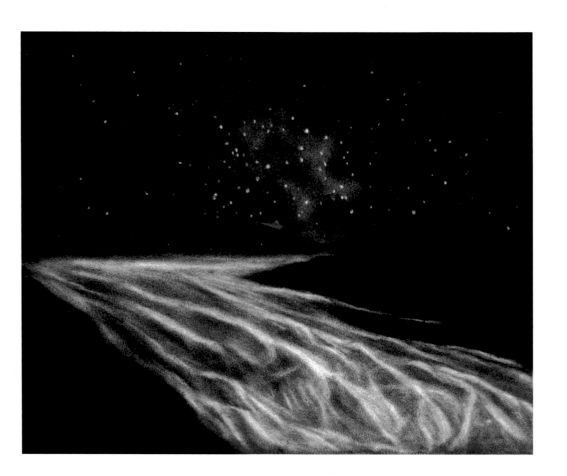

The sky's scrim
falls away:

Earth hurtles
into a chasm
of stars.

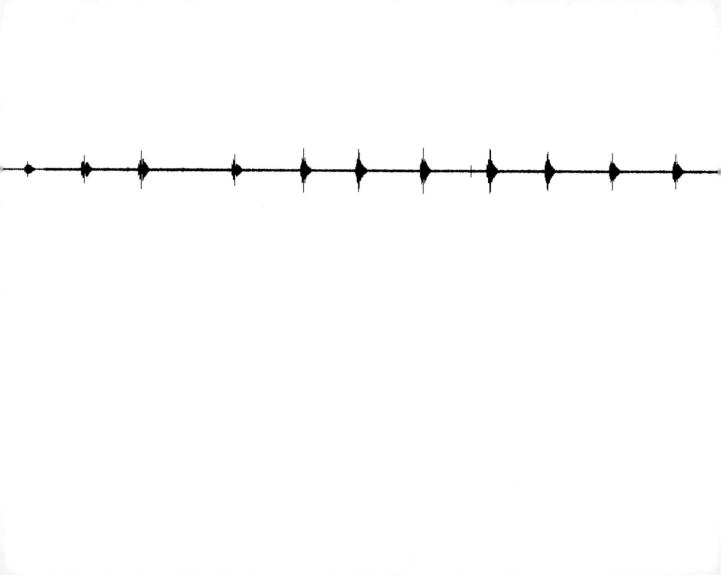

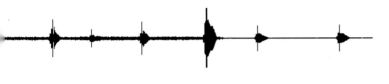

Feral angels
roar
in the treetops

unmoored
from the construct
of mercy

Oh what
was thought

that spume adrift
on unfathomable
oceans
that ocean
spray
tossed up to tangle
a moment
with the light
that spider's silk
spun
of nothing
and

gone

NOTES

Speak, Genoa.
What have you done?

Gabriele de' Mussis. *Istoria de Morbo sive Mortalitate quae fuit Anno Domini MCCCXLVIII* ["History of the Disease, or The Great Dying of the Year of Our Lord 1348"]. Trans. by Rosemary Horrox, in *The Black Death*. Manchester University Press. 1994. Trading ships sailing from Genoa spread plague to the ports of Europe.

Margaret, are you grieving
Over Goldengrove unleaving?

Gerard Manley Hopkins. "Spring & Fall: To a Young Child." 1918.

…we shall fight in the hills;
we shall never surrender…

Winston Churchill. June 4, 1940.

Such' ihn über'm Sternenzelt!
Über Sternen muß er wohnen.

[Seek him beyond the stars!
He must dwell beyond the stars.]

Ludwig van Beethoven. Symphony No. 9 in D Minor, Op. 125, "Choral." Text by Friedrich Schiller. 1785.

O dark dark dark.

T. S. Eliot. "East Coker." *Four Quartets*. 1943.

Yellow-naped Amazon parrots … ever the same.	Karl S. Berg, et al. "Vertical transmission of learned signatures in a wild parrot". *Proceedings of the Royal Society*. 2012.
In 1903, an observer in Nantucket…	F. Schuyler Mathews. *Fieldbook of Wild Birds and Their Music*. 1904.
Who would want to live in a world which is just not quite fatal?	Rachel Carson. *Silent Spring*. 1962.
four dots / dot dash dot	Morse code. "HR" (abbreviation for "here").
All changed, changed utterly: A terrible beauty is born.	William Butler Yeats. "Easter, 1916." 1920.
…where … torn fire glares / On beauty with a rusted mouth, — // Where something dreadful and another / Look quietly upon each other.	Louise Bogan. "A Tale." *Body of This Death*. 1923.

despoblados

Utterly deserted, uninhabited places. "[In] Chernobyl…trees in the infamous Red Forest—an area where all of the pine trees turned a reddish color and then died shortly after the accident—did not seem to be decaying, even 15 to 20 years after the meltdown."
Rachel Nuwer. Smithsonian.com. March 14, 2014.

taphonomy

The various means by which fossils form, from the Greek, "laws of burial." Described are distillation, pyritization, and petrifaction.

Colorless green ideas sleep furiously.

Noam Chomsky. *Syntactic Structures*. 1957.

A thing of beauty is a joy for ever:
Its loveliness increases; it will never
Pass into nothingness;

John Keats. *Endymion*. 1818.

If there must be a god in the house,
let him be one / That will not hear us
when we speak; a coolness, // A
vermilioned nothingness, any stick of
the mass / Of which we are too
distantly a part.

Wallace Stevens. "Less and Less Human, O Savage Spirit." 1947.

IMAGES

In order of appearance — all images by Karinna Gomez unless otherwise noted.

Sleep Drawing VII, etching, 2014

Song for Dead Sparrows, score by Syrinx Effect, hand drawn by Kate Olson, 2016

Mountain Radio Towers, mezzotint, 8"x 11", 2014

All Sky Camera (recording)… Sleep Waves, mezzotint, 8½" x 10", 2013

Island Wind Reading, mezzotint, 8" x 10", 2013

Subarctic Garden, mezzotint, 9½" x 9", 2013

Mountain Memory, mezzotint, 3" x 4", 2014

Sleep Drawing II, mezzotint, 5" x 7", 2014

Forest Substation, mezzotint, 8½" x 10", 2014

Sleep Hole II, mezzotint and soft-ground etching, 8⅞" x 8⅞", 2013

Sleep Hole, mezzotint and drypoint, 11⅛" x 11¾", 2015

Sleep Drawing, mezzotint, 5" x 7", 2014

Sleeping Reindeer, mezzotint, 6" x 8", 2014

High Latitude Rocket Launch, mezzotint, 6" x 8½", 2015

Look for the Glacier at Night, mezzotint, 5" x 7", 2013

Sonogram of the call of the seaside sparrow (dusky), *Ammodramus maritimus nigrescens*

Biographies

Melinda Mueller trained as a biologist and is on the science faculty at Seattle Academy of Arts & Sciences. Her most recent book, *What the Ice Gets: Shackleton's Antarctic Expedition, 1914-1916* (Van West & Company) received a 2001 Washington State Book Award and the American Library Notable Books Award for Poetry in 2002. Her other books of poetry are *Private Gallery* (Seal Press, 1976), *Asleep in Another Country* (Jawbone Press, 1979), and *Apocrypha* (Grey Spider Press, 1988). Melinda was a coauthor of an early list of rare, threatened, and endangered plant species of Washington State.

Karinna Gomez is an adjunct instructor at the University of Alaska Fairbanks, where she completed her MFA in 2014. She has received several awards, including a Fulbright Fellowship to study in Iceland and a Rasmuson Foundation Individual Artist Project Award. Karinna was recently an artist-in-residence at Anderson Ranch Arts Center in Colorado and at Galleri Christensen in Kjøllefjord, Norway. Her work is shown and collected nationally. She is represented by Davidson Galleries in Seattle.

Syrinx Effect is the interstellar folk-punk jazz duo of **Kate Olson** on soprano saxophone and **Naomi Siegel** on trombone, plus their pedals, laptop, and other toys. The duo got its start curating the Racer Sessions in Seattle and has gone on to perform prolifically around the US, collaborating with many of the mainstays of the improvised music scene, such as Wayne Horvitz, Robin Holcomb, Elliott Sharp, Bobby Previte, Stuart Dempster, Allison Miller, and Rene Hart. Both maintain busy schedules pursuing individual projects, teaching, and performing with Seattle's jazz and world music scene. Their first full-length album, *A Sky You Could Strike a Match On*, is being released in the fall of 2016.

Audio

I.

Song for Dead Sparrows
Written and performed by Syrinx Effect (Kate Olson & Naomi Siegel).
Commissioned for *The After*.

II.

The After
Read by Melinda Mueller.
Recorded at Skoor Sound, Seattle, Washington.

III.

Field recording of Ammodramus maritimus nigrescens — *seaside sparrow (dusky)*, *extinct 1987*
Robert C. Stein and William W. H. Gunn, 1963.
Courtesy of the Macaulay Library at the Cornell Lab of Ornithology.